Kimmie's

Closet

A Fun Fashions Coloring Book

By: Yvonne R. Green-Evans

Bloomington, IN authorHOUSE Milton Keynes, UK

AuthorHouse™
1663 Liberty Drive, Suite 200
Bloomington, IN 47403
www.authorhouse.com
Phone: 1-800-839-8640

Published by AuthorHouse 4/19/2013

ISBN: 978-1-4259-1422-6 (sc)
ICBN: 978-1-4772-0116-9 (e)

Printed in the United States of America
Bloomington, Indiana

This book is printed on acid-free paper.

Dedicated to: **Kim and Mondre**,
and especially, to Morgan and Sydney for their inspiration.

The title, "Kimmie's Closet" is registered in the U.S. Patent and Trademark Office

Cover design by Yvonne R. Green-Evans.

Hello Young lady,

I hope you will chose to take a copy of "Kimmie's Closet" home with you to enjoy. Use your creativity to add your own touch to the fashions in this coloring book. Try adding bows flowers, hearts, butterflies etc. to make your own fashion statement. Also, there are many new varieties of color choices for you to choose from. Including some of the more glittery colors.

Each page has its own frame and will fit easily into a picture frame for sharing with friends, hanging in your room or giving as fun gifts.

Have Fun !
Kimmie's Mom

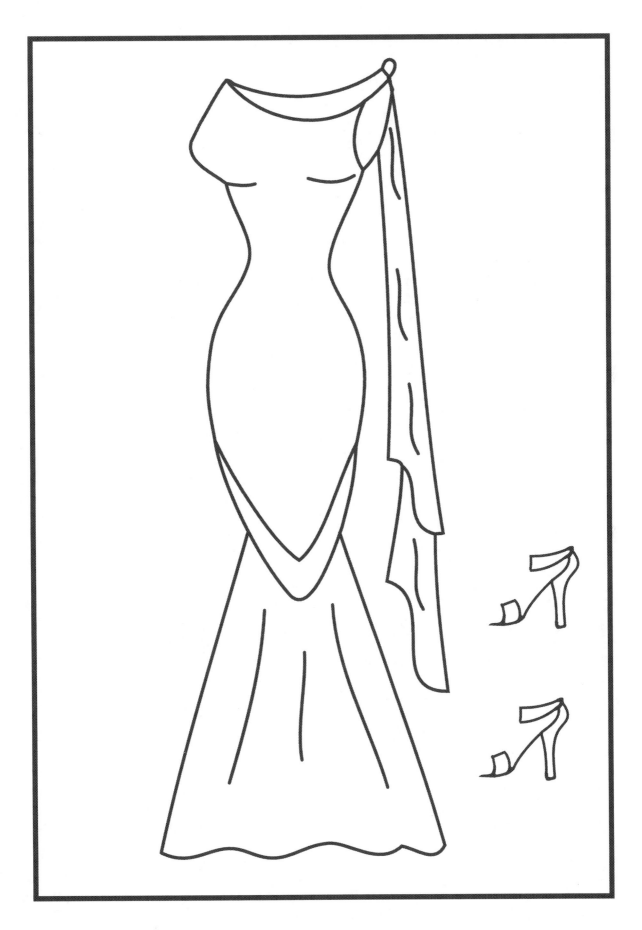

Colored By: _____

Date: _____

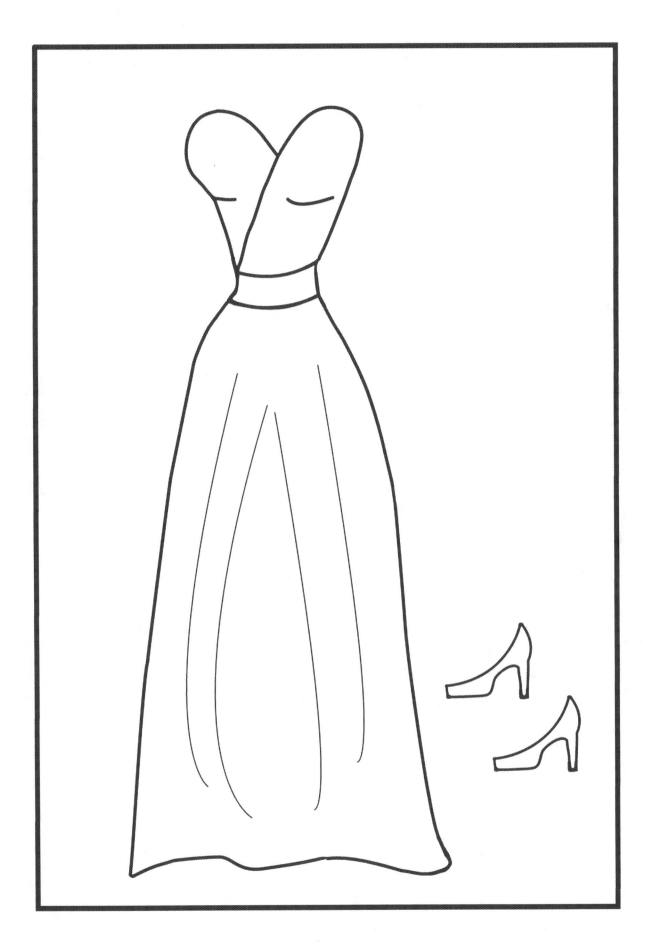

Colored By: _____

Date: _____

Colored By: _____

Date: _____

Colored By: _____

Date: _____

Colored By: _____

Date: _____

Colored By: _____

Date: _____

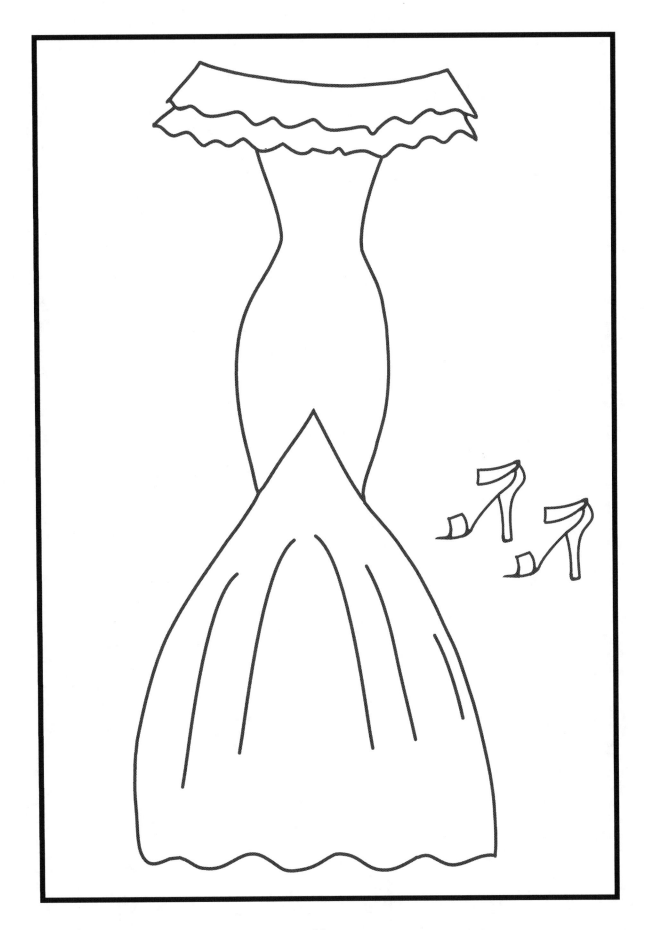

Colored By: _____

Date: _____

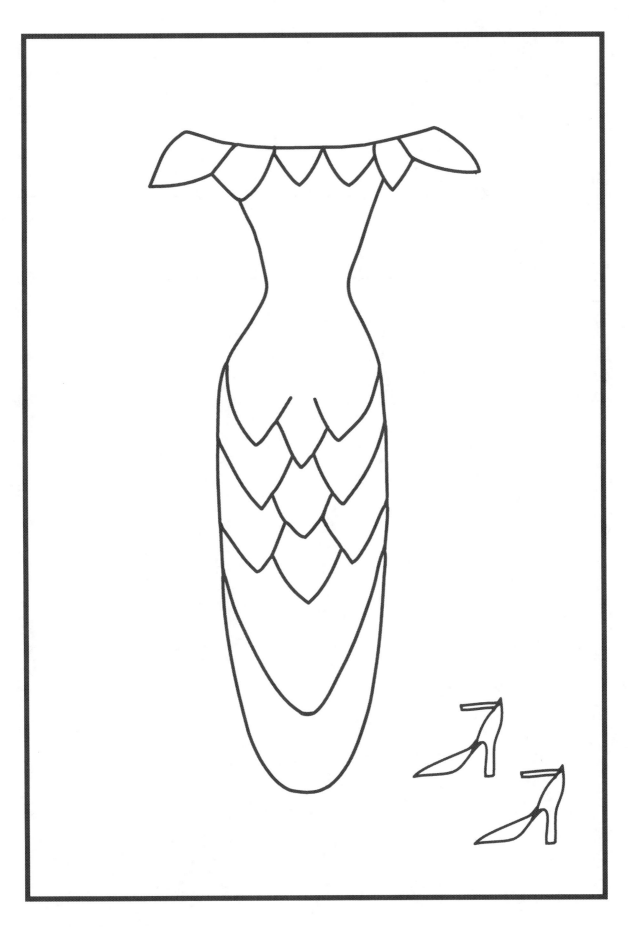

Colored By: _____

Date: _____

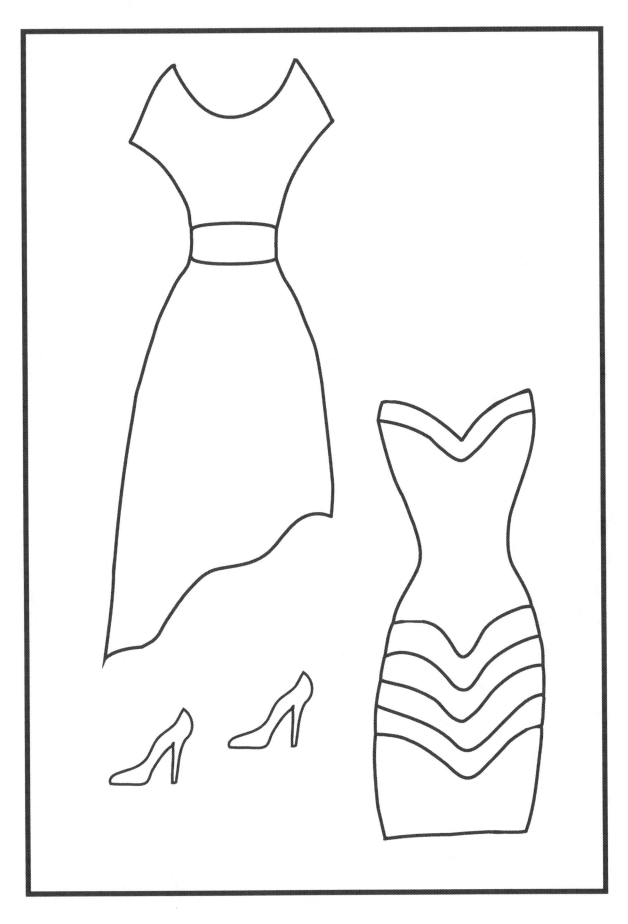

Colored By: _____

Date: _____

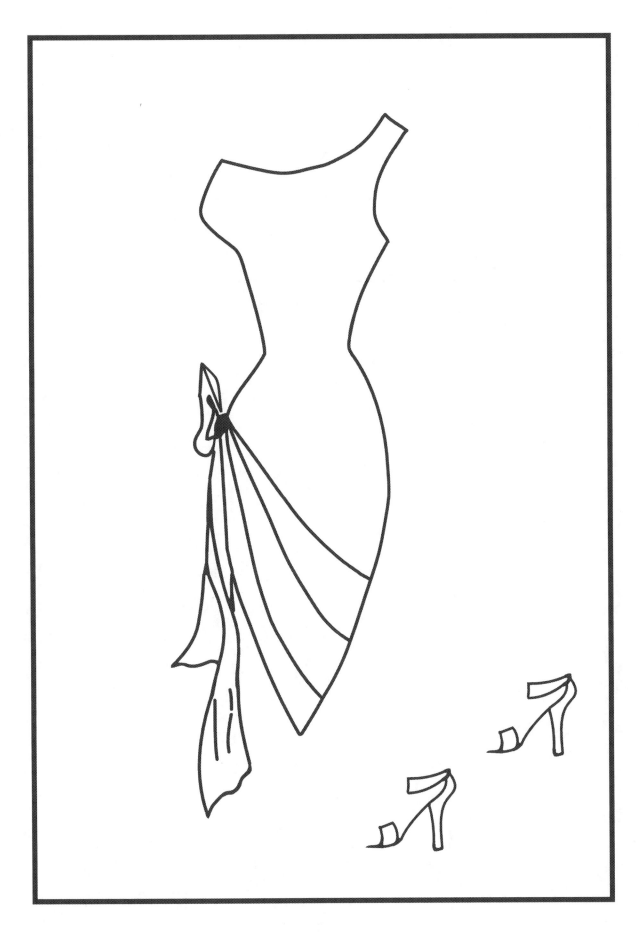

Colored By: _____

Date: _____

Colored By: _____

Date: _____

Colored By: _____

Date: _____

Colored By: _____

Date: _____

Colored By: _____

Date: _____

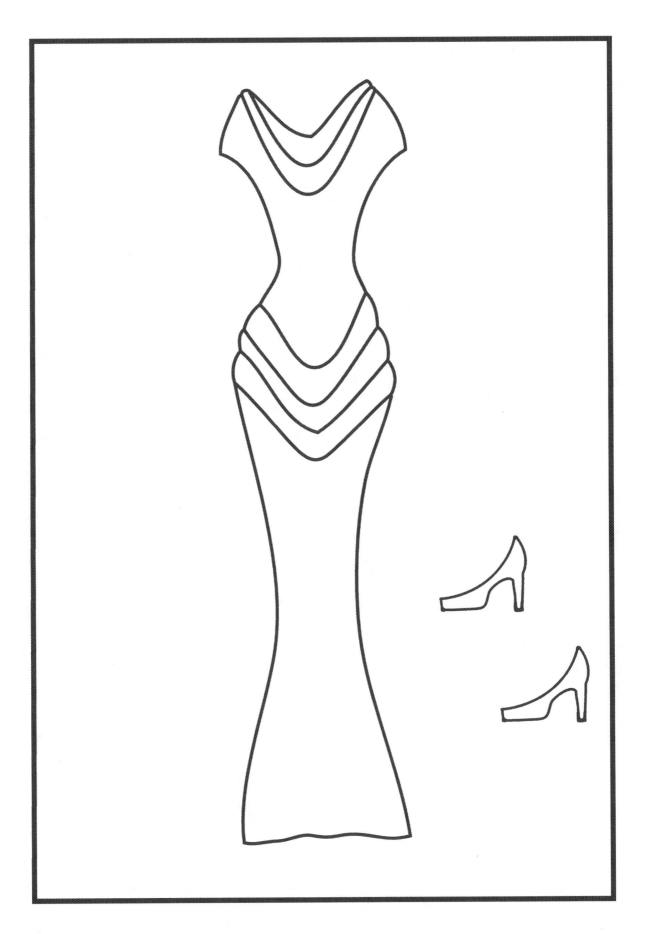

Colored By: _____

Date: _____

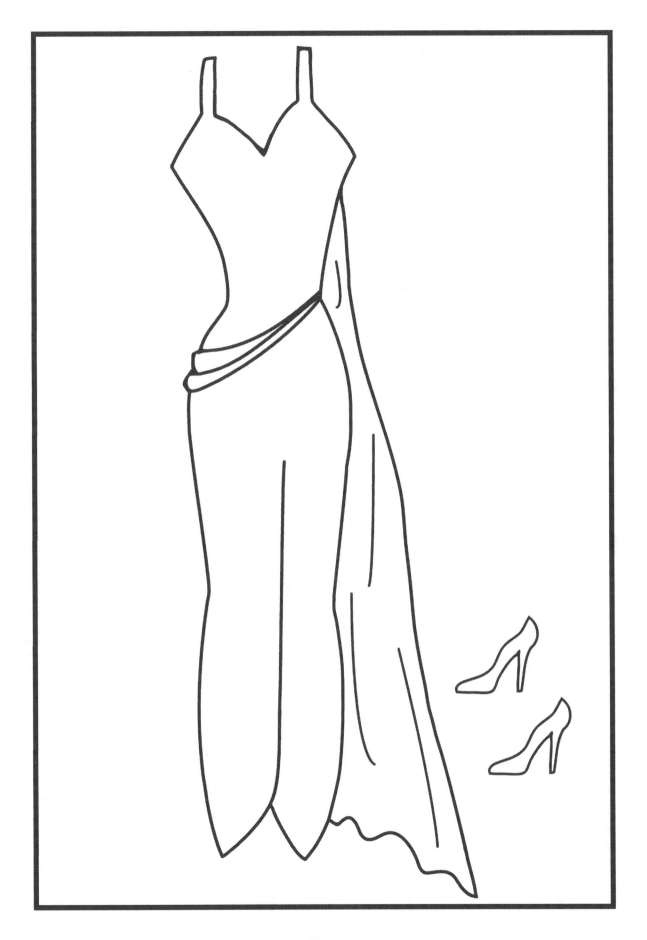

Colored By: _____

Date: _____

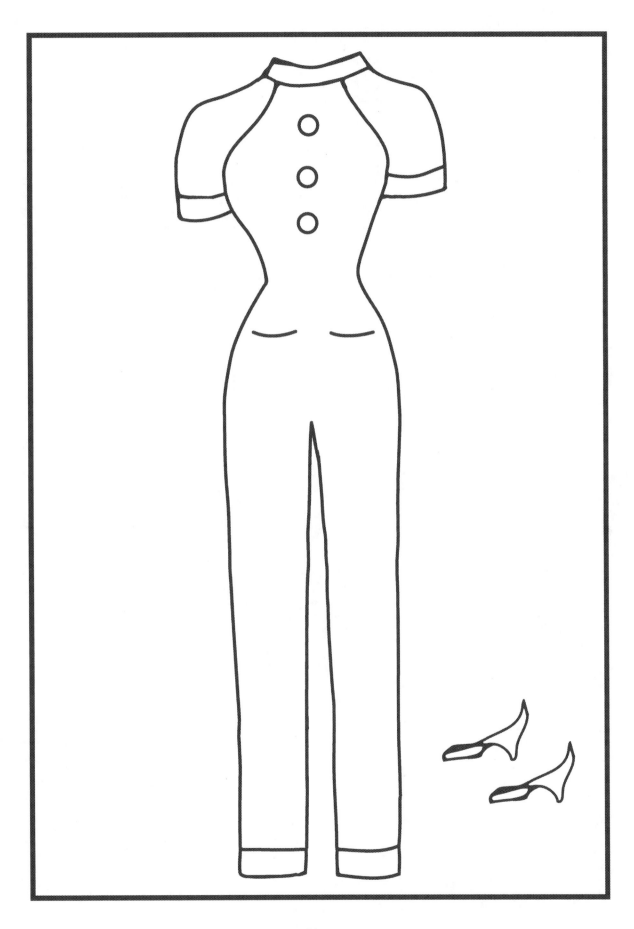

Colored By: _____

Date: _____

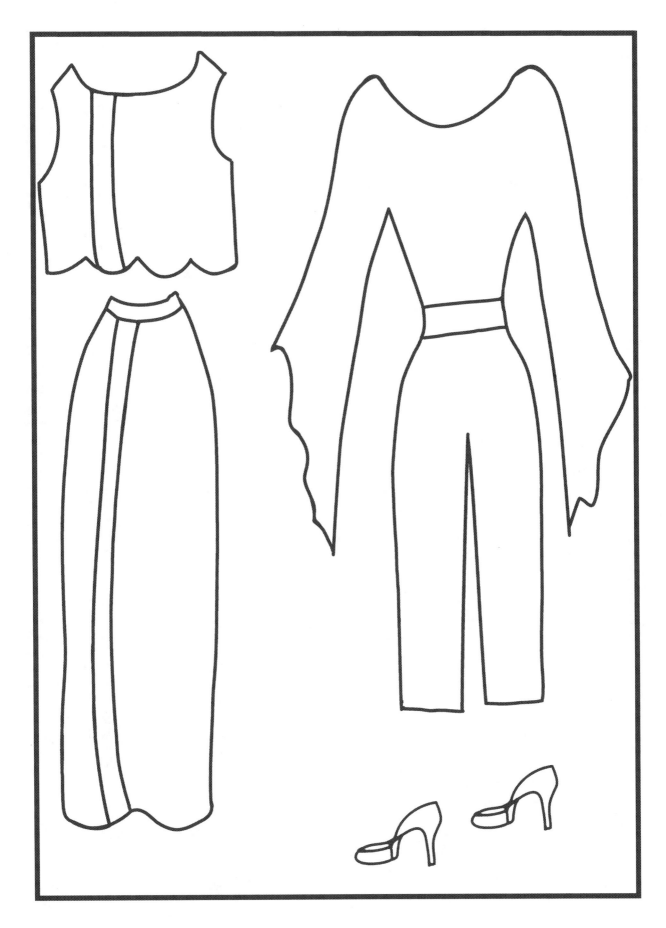

Colored By: _____

Date: _____

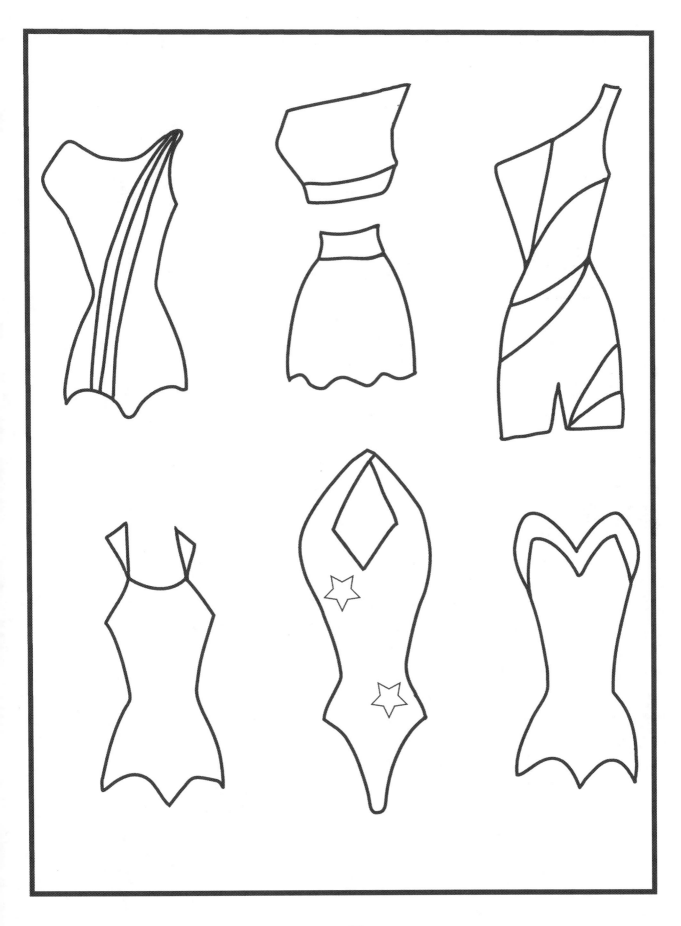

Colored By: _____

Date: _____

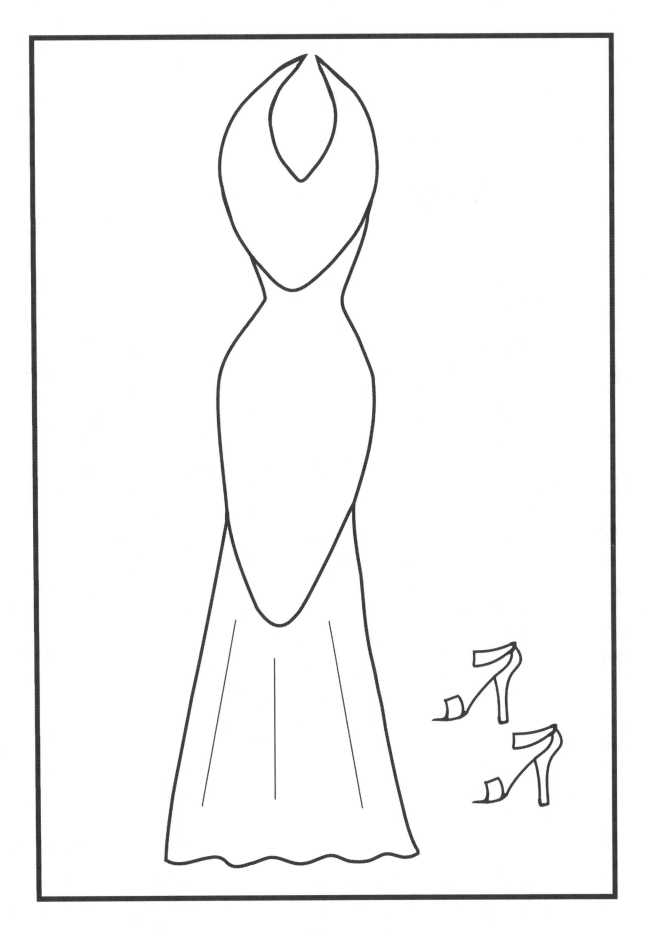

Colored By: _____

Date: _____

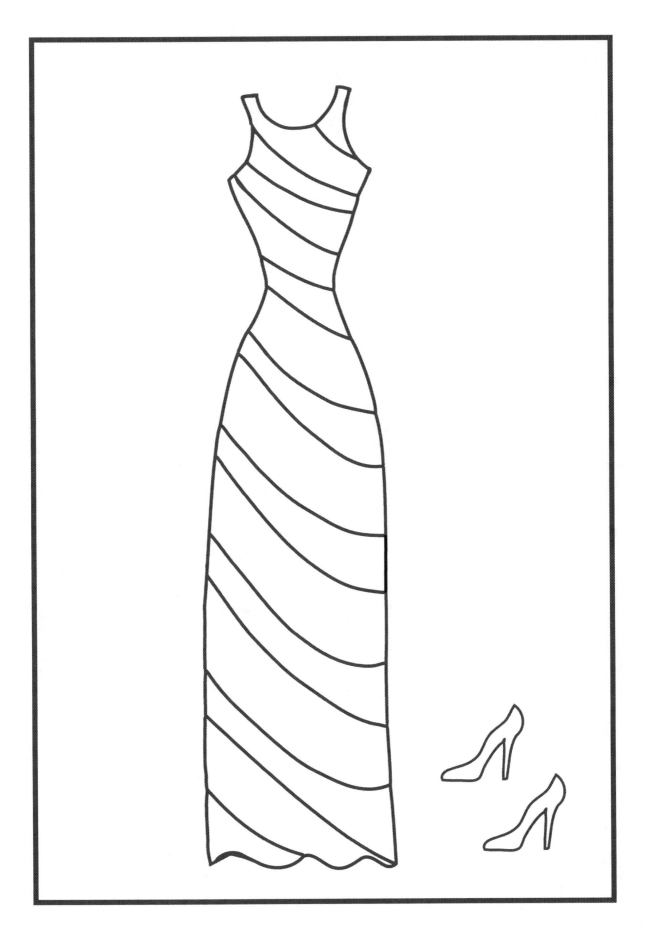

Colored By: _____

Date: _____

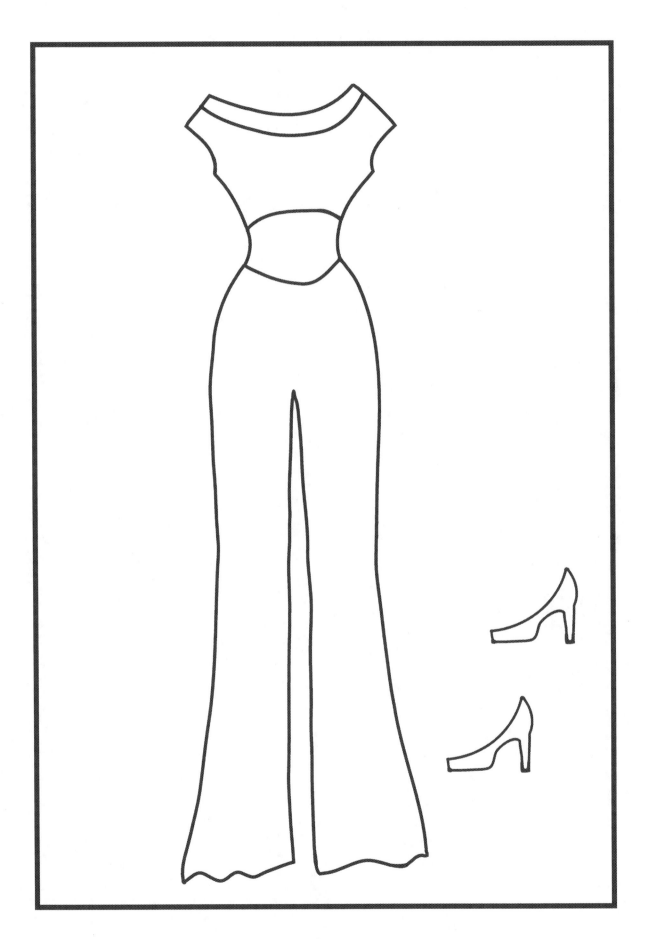

Colored By: _____

Date: _____

Colored By: _____

Date: _____

Colored By: _____

Date: _____

Colored By: _____

Date: _____

Colored By: _____

Date: _____

Colored By: _____

Date: _____

Colored By: _____

Date: _____

Colored By: _____

Date: _____

Colored By: _____

Date: _____

Colored By: _____

Date: _____

Colored By: _____

Date: _____

Colored By: _____

Date: _____

Colored By: _____

Date: _____

Colored By: _____

Date: _____

Colored By: _____

Date: _____

Colored By: _____

Date: _____

Colored By: _____

Date: _____

Colored By: _____

Date: _____

Colored By: _____

Date: _____

Colored By: _____

Date: _____

Colored By: _____

Date: _____

Colored By: _____

Date: _____

Colored By: _____

Date: _____

Colored By: _____

Date: _____

Colored By: _____

Date: _____

Colored By: _____

Date: _____

Colored By: _____

Date: _____

Colored By: _____

Date: _____

Colored By: _____

Date: _____

Colored By: _____

Date: _____

Colored By: _____

Date: _____

Colored By: _____

Date: _____

Colored By: _____

Date: _____

Colored By: _____

Date: _____

Colored By: _____

Date: _____

Colored By: _____

Date: _____

Colored By: _____

Date: _____

Colored By: _____

Date: _____

119

Colored By: _____

Date: _____

Colored By: _____

Date: _____

Colored By: _____

Date: _____

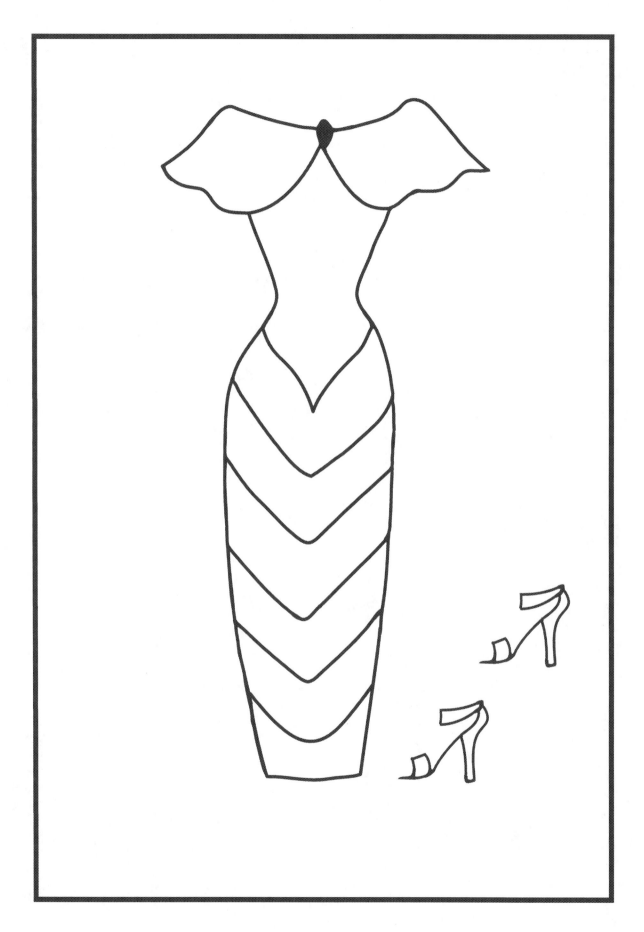

Colored By: _____

Date: _____

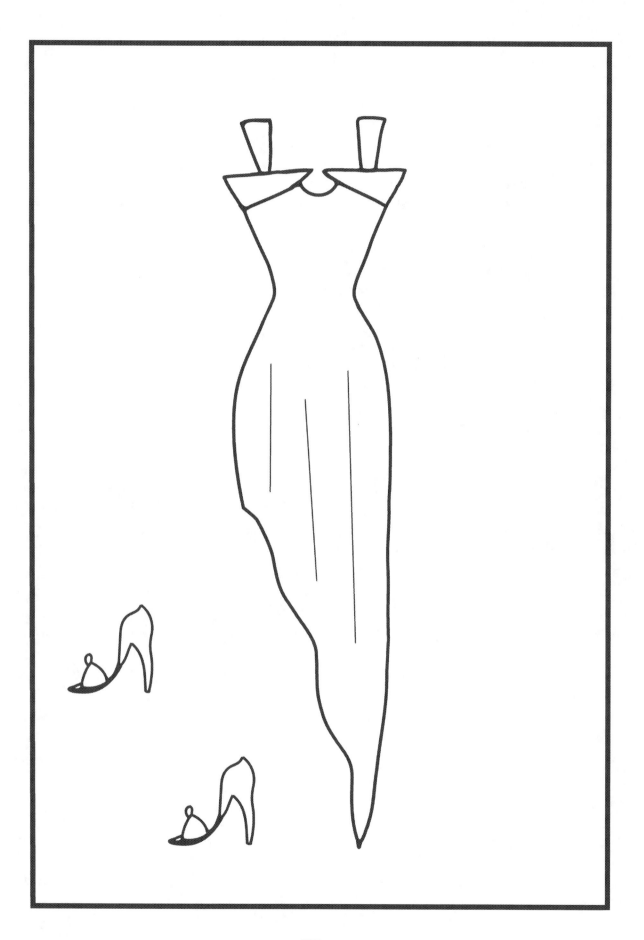

Colored By: _____

Date: _____

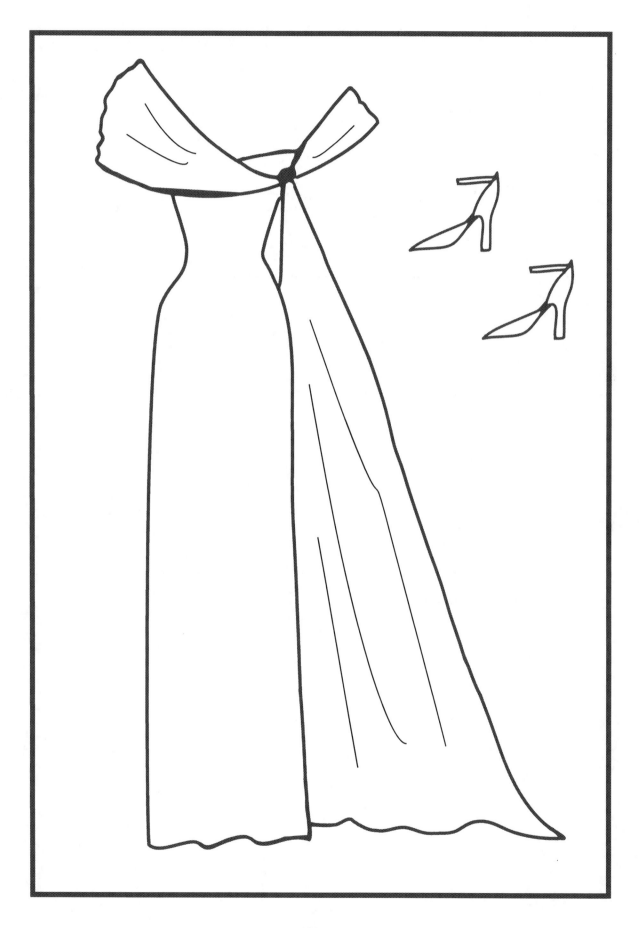

Colored By: _____

Date: _____

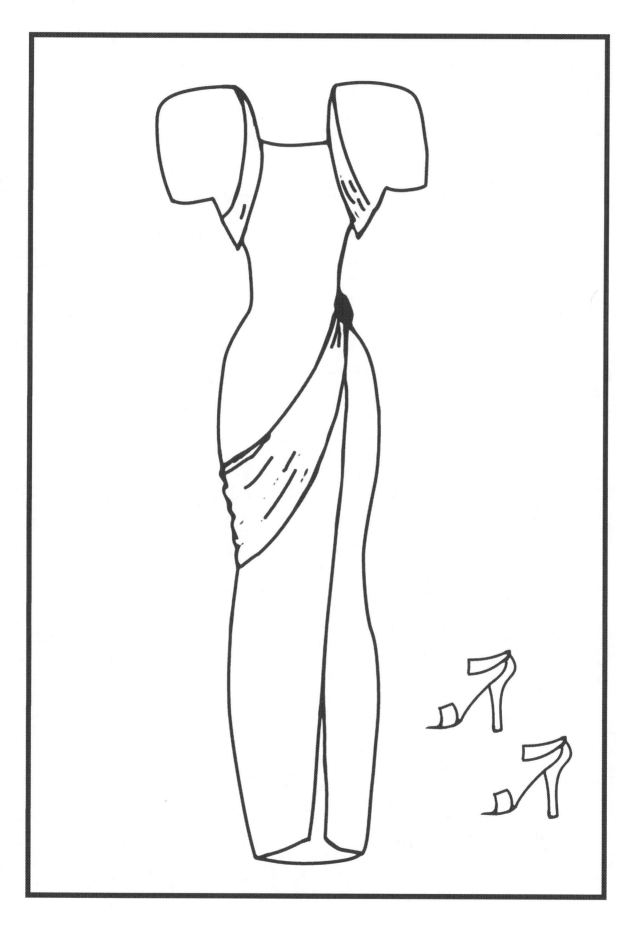

Colored By: _____

Date: _____

Colored By: _____

Date: _____

Colored By: _____

Date: _____

Colored By: _____

Date: _____

Colored By: _____

Date: _____

Colored By: _____

Date: _____

Colored By: _____

Date: _____

Colored By: _____

Date: _____

Colored By: _____

Date: _____

Colored By: _____

Date: _____

Colored By: _____

Date: _____

Colored By: _____

Date: _____

Colored By: _____

Date: _____

Colored By: _____

Date: _____

Colored By: _____

Date: _____

Colored By: _____

Date: _____

Colored By: _____

Date: _____

165

Colored By: _____

Date: _____

Colored By: _____

Date: _____

Colored By: _____

Date: _____

Colored By: _____

Date: _____

Colored By: _____

Date: _____

Colored By: _____

Date: _____

Colored By: _____

Date: _____

Colored By: _____

Date: _____